*Lives of*

*Rubens*

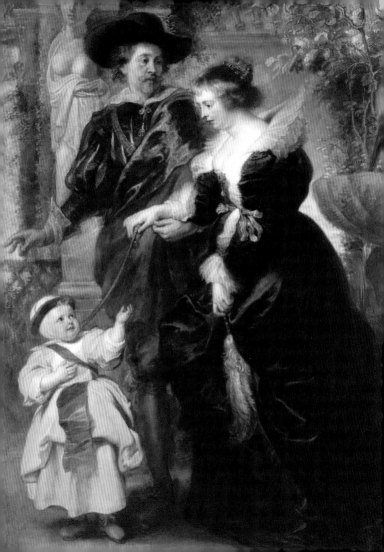

# Lives of Rubens

Giovanni Baglione

Joachim von Sandrart

Roger de Piles

introduced by
Jeremy Wood

The J. Paul Getty Museum, Los Angeles

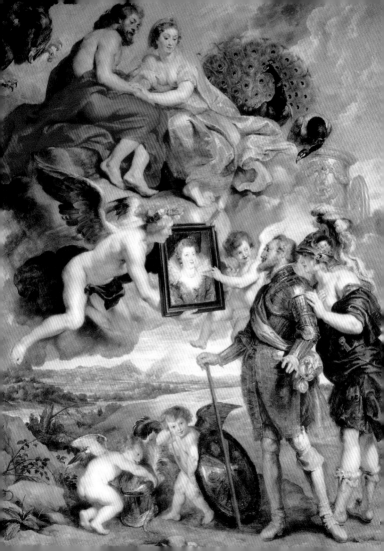

# CONTENTS

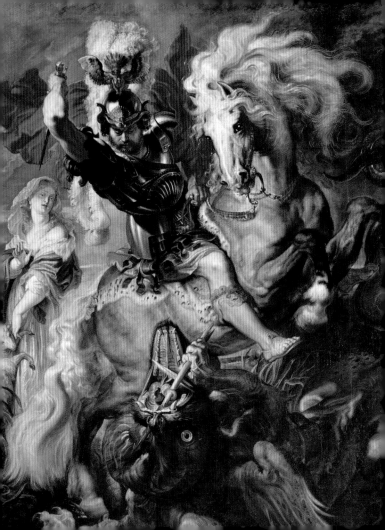

# INTRODUCTION

*JEREMY WOOD*

When Peter Paul Rubens approached his death in 1640 he was able to look back on a lifetime's work that was astonishing for its vitality, human insight, and range. At one extreme he could work on a small scale and was even prepared to paint the figures in cabinet pictures where a specialist would add the landscape background or still-life details, but, as he himself said in a much-quoted letter, 'my talent is such that no undertaking, however vast in size or diversified in subject, has ever surpassed my courage'. He knew how to delight a spectator who looked at his works close to the painted surface or far away on a ceiling or a high altar. Rubens, who thought deeply about what he painted and was a truly learned man, never paraded his knowledge and seems to have had an instinctive sense of how to make his work both legible and accessible.

By the end of the seventeenth century it was clear that Rubens had changed what people thought about

*Opposite: St George and the Dragon, c. 1606-7; Rubens kept this picture all his life*

art and what they expected from artists. First, no artist before him, even the great Venetian painter Titian, had worked for such an international audience or been so little constrained by the city in which he chose to live. Secondly, no artist before him was to attract so much comment in print in the period following his death. The flow of biographies and critical discussions may have started as a trickle but, by the standards of the period at least, soon turned into a torrent that was addressed to an international audience. It says a lot that the selection of early texts that follow this introduction are the work of an Italian, a German and a Frenchman.

## Baglione's *Life*

The first biography of Rubens (which appeared in print only two years after his death) was written by a painter who lived and worked in Rome, Giovanni Baglione (1566-1643), and is to be found in his comprehensive account of the lives of the artists who had been active in that city during the previous five pontificates. It was largely put together during the 1620s and was published in 1642. Baglione may well have met Rubens during the period when the latter was in Rome, but there is not much that is personal or

anecdotal in his account. His approach was concise, factual, and informative. At one point he said, 'I write biographies of artists and I am not their judge.' He also produced a guidebook to nine of the pilgrimage churches in Rome and adopted a similarly literal approach in his lives of modern artists.

Rubens arrived in Italy in 1600 after studying with Otto van Veen in Antwerp, but, despite having little track record to recommend him, quickly entered the service of Vincenzo I Gonzaga, fourth duke of Mantua (1562-1612), as Baglione recounts. He established himself as a courtier before he became recognised as much of a painter, and in 1603 was trusted with a sensitive mission to the court of Philip III in Madrid, taking presents of works of art and paintings which did not, perhaps surprisingly, include anything by the artist himself. Nevertheless, by the end of eight years in Italy, he left Rome having completed one of the largest and most prestigious altarpieces of the period, discussed further below, which he had gained in the face of fierce competition from his rivals in Rome by lowering his fee, no doubt to the dismay of Baglione, who was then established as a leading member of the painters' trade union, the Academy of Saint Luke.

Not surprisingly, Baglione concentrates on the most visible monuments that Rubens left behind him

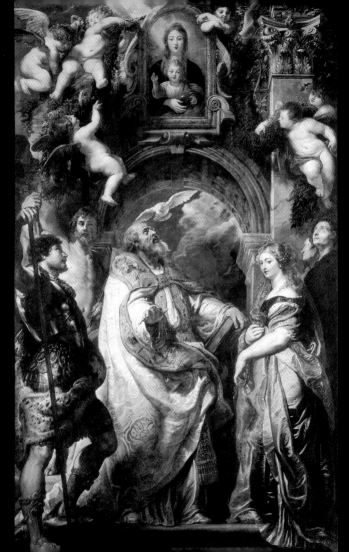

in Roman churches. The most important of these was the high altar in Santa Maria in Vallicella, also known as the Chiesa Nuova. It provides a fascinating example of the tricky nature of such commissions in Counter-Reformation Italy and of Rubens' ability to improvise in difficult circumstances. The patrons wished him to incorporate an ancient fresco of the Madonna that had been saved when an earlier church on the site was pulled down. Rubens' first version on canvas, now in the Musée des Beaux-Arts, Grenoble (ill. opposite), did not satisfy the patrons, perhaps because it caught the light but more likely because the fresco was not prominent enough. At any rate he was forced to redo the work. His solution was to spread the design over three large pictures painted on slabs of slate (which was less likely to be reflective), and he inserted the fresco by cutting a circular opening into the centre section, although the miraculous image itself was only visible on feast days; as Baglione notes, it was usually covered by a moveable copper shield on which Rubens painted a paraphrase of the Madonna in his own style. (These paintings, ill. pp. 28-29, are still in Santa Maria in Vallicella.)

*Opposite: The Virgin adored by St Gregory and other saints, 1607-8, the original altarpiece for Santa Maria in Vallicella*

JEREMY WOOD

## Rubens' reputation

Rubens could have remained in Rome had he so want-
ed, but, in 1608, he made the bold and perhaps
puzzling decision to return to Antwerp. Despite this
act of loyalty to his native land, he lacked a Flemish
biographer of any substance in the seventeenth centu-
ry, and as a result the early accounts of his work have
relatively little to say about the great series of altar-
pieces that he painted after returning, of which the
most crucial for his reputation were the *Raising of the
Cross* in Sint-Walburgis, Antwerp, and the *Descent
from the Cross* for Onze-Lieve-Vrouwekerk, the cathe-
dral. Instead, the writers presented here (who could be
supplemented by Francisco Pacheco, Giovanni Pietro
Bellori and André Félibien) have most to say about the
works that he painted for foreign courts in the later
part of his career, including the great cycles for Marie
de' Medici in Paris, Charles I in London, and Philip IV

*Opposite: The outer wings of the Descent from the Cross altarpiece
in Onze-Lieve-Vrouwekerk, Antwerp, c. 1611-14, showing
St Christopher and the Hermit.
Following pages: the open altarpiece, with The Visitation on the left
and The Presentation in the Temple on the right*

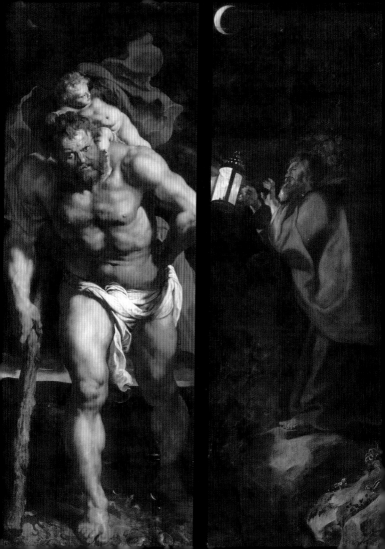

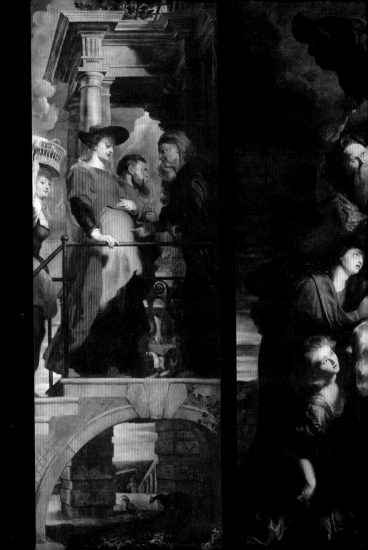

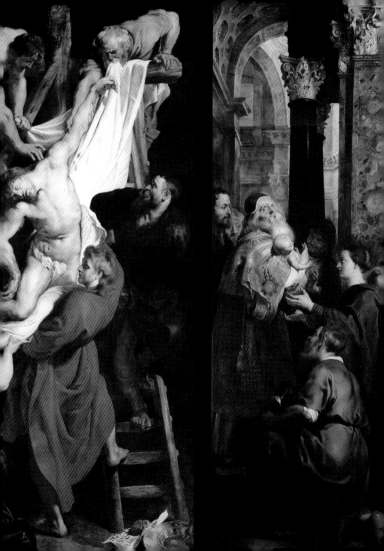

in Madrid, as well as the cabinet pictures that were easily transported by dealers between European cities. In addition, all his biographers and critics were familiar with the engravings that he issued to spread his reputation throughout Europe. This led to some convergence in what they had to say.

Rubens' biographers were also dazzled by the possibilities for social advancement and material wealth that his career seemed to open for artists, writing at length about his ennoblement by princes, and his dogged service as a diplomat who did the legwork negotiating what a contemporary called 'delusory treaties' between the Habsburgs and their Protestant opponents. This enterprise led to success on a personal level, since he gained the respect of just about everyone with whom he negotiated, and on a political level too, since Britain and Spain exchanged ambassadors and signed a truce. But on a larger scale his efforts could be counted a failure — perhaps the only significant failure that Rubens encountered in his entire career — and this led to his retirement from public life, although none of the biographers was so impolite as to suggest this, reserving their occasional criticisms for the less momentous sphere of his work.

Sandrart's *Life*

The second text to be chosen for the present book was written by the alarmingly cosmopolitan Joachim von Sandrart (1606-1688), a painter of limited ability, who had been born in Frankfurt am Main and who had the advantage of meeting Rubens personally, if briefly. His vain and badly written study of art, based on excessive reading, is nevertheless a mine of valuable information since he seems to have been everywhere and met everyone in the first half of the seventeenth century. It appeared in a German edition in 1675 and a Latin one in 1683.

At the core of Sandrart's biography of Rubens is an eyewitness account of his reception by a number of Dutch painters in Utrecht in 1627. Sandrart's account shows the huge esteem in which Rubens was held at this point in his career and his personal tact, not least when confronted with one of the German artist's own paintings. Soon after, he set out for Amsterdam by boat accompanied by Sandrart, who recounts in another part of his book how Rubens told him about his admiration for the sixteenth-century prints of

Albrecht Dürer, Hans Holbein, and Tobias Stimmer, and how he had copied their work as a young man. This is not the most important episode in his busy career, but it is a rarity, since far more documentation survives for his activity as a diplomat than for his dealings with other artists.

## De Piles and Rubens

The last two texts to appear in the present selection were written by the great critic Roger de Piles (1635-1709), who engaged in a combative defense of Rubens' work in the face of criticism from the French admirers of Nicolas Poussin. In February 1676, Rubens' nephew Philip sent a short biography of his uncle in Latin to a merchant, Picart, in Paris. In March he received a letter from de Piles, who wanted more information in order to flesh it out and get a version into print, which appeared soon after and was reissued in 1681. Philip Rubens' material allowed de Piles to write an account in which the artist's character, his public career and the conduct of his life come to the fore. De Piles wrote elsewhere about the power of Rubens' work as a painter, in

particular, in the 'Reflections' which he added to another, shorter life found in a collection of artists' biographies published in 1699. This represents a different side to de Piles' work as a critic, one that is more engaged with the language of painting and its visual seductions.

For de Piles, Rubens excelled in making pictures that had an overall harmony and balance between their separate parts. One of the most vivid ways he found of conveying this unity was through the metaphor of a bunch of grapes, an idea that purportedly went back to something Titian had said. For de Piles the spherical grapes, some seen in the light and some shadowed, some with bright hues and some obscured, were a parallel for the component parts of a painting, and it is easy to see how this metaphor could be applied to Rubens multi-figure compositions such as the *Fall of the Damned* in the Alte Pinakothek, Munich (ill. p. 105), or *The Rape of the Sabine Women* in the National Gallery, London (ill. overleaf), both of which were known to de Piles and discussed by him in detail at various times.

*Overleaf: The Rape of the Sabine Women, c. 1635-40*

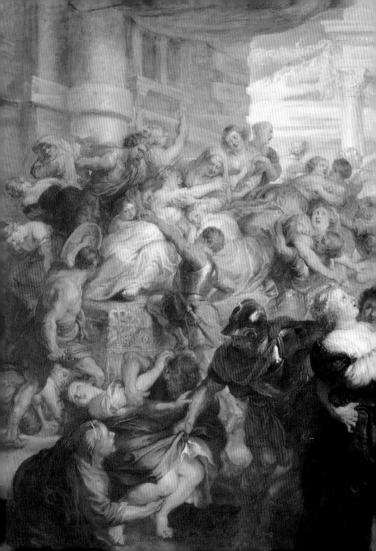

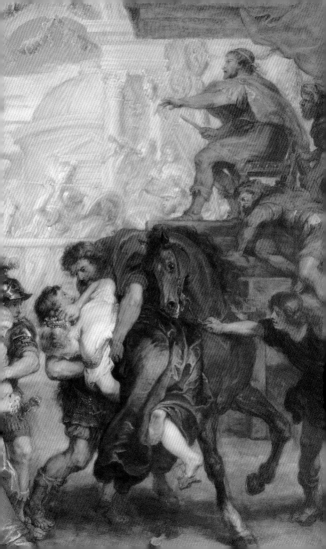

De Piles' metaphor also holds good in a different way. Rubens conceived his works organically, not as arrangements within a frame, so he often designed groups of figures that could be moved around within the picture space or added and subtracted at will. When painting on panel he was quite capable of having strips of wood added to the edges while he worked, so that the composition gradually expanded from a central core in ways that could not have been predicted from the start. It seems to me that anyone who wants to understand Rubens' work needs to consider these very flexible and improvisatory habits of mind.

Reading the early biographies forces one to think about the links between Rubens' life and his work, and the way that the critical reception of that work has shaped and sometimes distorted our understanding of it. Rubens was clearly the antithesis of his belligerent, antisocial and self-destructive contemporary, Michelangelo da Caravaggio, whose life and work have proved so fascinating in the recent past. But, if Caravaggio's work is sometimes bitter to the taste, Rubens offers a more humane, more humorous, and more inclusive antidote.

# GIOVANNI BAGLIONE

*The Life of
Peter Paul Rubens,
Painter*

**from**

*Le vite de' pittori, scultori
et architetti*

1642

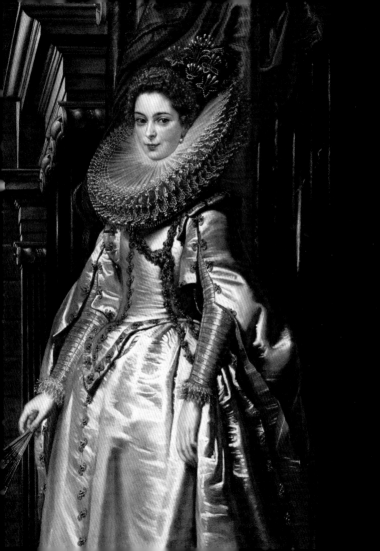

**P**ainting is no less to be prized than the dealings of lords, which create laws and govern the people, just as the painter tempers and masters his brush.

During the pontificate of Clement VIII a young Fleming came to Rome, called Peter Paul Rubens, who had spent some time in Mantua in the service of his Highness there, and had executed numerous works for him. In particular he painted several very beautiful portraits. He came to this Court of the World, Rome, in order to perfect his talent, and seeing and studying the exquisite works of this admirable city, both ancient and modern, he acquired good taste and learnt how to paint in the fine Italian manner.

He was commissioned to decorate the lower church of Santa Croce in Gerusalemme in the chapel dedicated to St Helena, mother of the great emperor Constantine, which had been restored by the cardinal Archduke Albert of Austria. On the main altar he depicted St Helena in an act of devotion embracing the cross of our Saviour, with playful cherubs all around. The painting is executed in perspective. It is a work in oil executed with great care.

*Opposite: The Marchesa Spinola Doria, 1606; painted in Genoa*

Above the altar to the right he has depicted Jesus crowned with thorns with various figures around, in dark colours, as if it were night. In the other painting to the left is the Crucifixion of our Saviour with several evildoers in the act of trying to raise the Cross: they are very good figures, as is that of Christ, and with him the three Maries with a noble woman who has fainted; all quite graceful, painted in oil, with vigour and good taste.[1]

In the church of the Fathers of the Oratorio della Vallicella he executed a large painting for the main altar. Above he depicted the Virgin and Child, with many beautiful cherubs, and below St Gregory Pope and other saints. It is a very good painting, but it was not placed above the altar because the strong light shining directly on it took away the pleasure of looking at it, and so it was placed elsewhere.[2]

So above the main altar he depicted the Virgin with the Christ Child in her arms, which is removed during the main religious festivals so that one may see the miraculous ancient image of the Blessed Virgin which is conserved behind it, and is seen with cherubs all around and, below, several kneeling

1. These three paintings, executed 1601-2, are now in the municipal hospital, Grasse, although the *Crucifixion* is a later copy    2. Now Musée des Beaux Arts, Grenoble, ill. p. 10

angels that adore the Holy Sacrament and revere the Blessed Virgin.

To the right of the altar on the choir façade there is a large painting depicting St Gregory, St Maurus in ancient military dress and St Papianus Martyr with cherubs above: a very good painting executed in a fine manner.

And facing this to the left is another large work depicting St Domitilla and the martyrs Sts Nereus and Achilleus with cherubs above carrying palms, painted in oil on slate with good taste.[1]

Rubens executed various works for various illustrious people, and in particular for certain Genoese gentlemen he executed with care from nature large, life-size equestrian portraits and the like. And in this genre he had few equals.

Later he desired to return to his native town of Antwerp and from there he went to the court of the Archduchess of Austria, where he was greatly esteemed by Her Highness. He executed several works to the taste of the princess, who always treated him well in every circumstance.

1. Commissioned by the Oratorians in 1606 and all three still in situ

*Overleaf altarpiece and flanking paintings in Santa Maria in Vallicella, 1608. Centre: Madonna adored by angels; left: Sts Gregory, Maurus and Papianus; right: Sts Domitilla, Nereus and Achilleus*

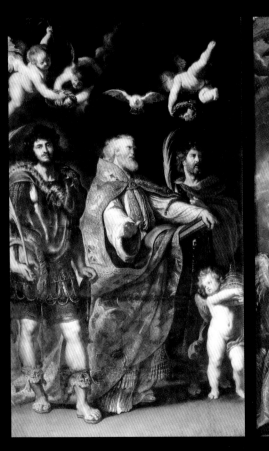

He was called to France by the Queen Mother and there he painted a gallery which brought him great satisfaction and for which he was well paid by Her Majesty.[1]

Returning to Flanders to high acclaim, he executed several large works which were also printed, some as woodcuts, others exquisitely engraved. Amongst the most famous we should mention: the Battle of the Amazons, six feet square; St Rocco, reputedly the best of all; three Crucifixions, each one different; an Entombment; the Battle of the Lions; the Conversion of St Paul; the Navicella; a Nativity with Shepherds; the Adoration of the Magi bearing gifts for the Christ Child; the Head of King Cyrus; the Judgement of Solomon; the Mystical Marriage of St Catherine; the Two Susannas; and ceiling paintings which have ennobled not only Rome but all parts of Europe.[2]

1. The Marie de' Medici cycle, 1621-25, in the Louvre, Paris. See note p. 42 and ills. on pp. 4, 43 and 78-79.    2. This list is not accurate or specific enough to identify with certainty the pictures that Baglione means, though the Alte Pinakothek, Munich, has a *Battle of the Amazons*, and a *Lion Hunt*; the crucifixions might include the *Descent from the Cross* in Antwerp Cathedral, ill. pp. 14-15; and the Cyrus may be the *Cyrus and Tomyris* in the Museum of Fine Arts, Boston.

*Opposite: The Entombment, c. 1612*

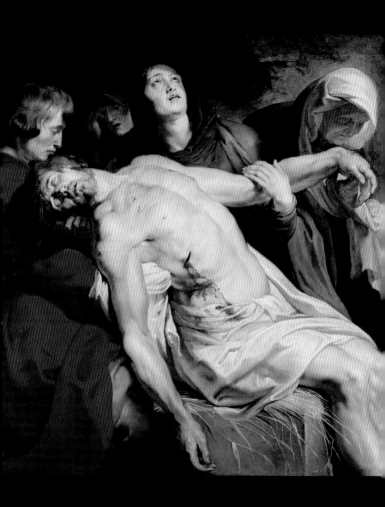

Rubens also executed coloured cartoons for tapestries, since here in Rome some very fine ones are to be seen, with diverse capricci and a variety of inventions, designed with vigour and charm and decorated with fantastic borders. They are very beautiful tapestries. Truly Peter Paul Rubens has shown the world that he is a universal painter, full of a variety of inventions, and he has executed his works with great vivacity and naturalness. It is many years since Flanders has seen a better painter, or one who has so felicitously adopted the fine Italian manner.

Peter Paul Rubens was gifted not only with the talent of painting, but he also had excellent and wide-ranging diplomatic skills, and so the Marquis Ambrogio Spinola suggested sending him to the English court in order to negotiate peace between the Crowns of England and of Spain. Rubens was called to Spain, where he was well received by the King, who appointed him ambassador. And so he went to England, where he was received by that court with great honours. He undertook the important negotiations with much grace and skill, concluding them to the satisfaction of both potentates. The King before his Parliament drew his sword from its

*Opposite: The Education of Achilles, tapestry design, 1630-35*

sheath to dub Rubens, gave him a diamond ring from his own finger worth thousands of scudi, as well as a hatband of the finest diamonds, worth about ten thousand scudi, and appointed him his knight.

Returning to Spain Peter Paul was received with great applause by His Majesty who, showing himself greatly pleased with the negotiations, declared Rubens a member of his Chamber and conferred upon him the honour of the Golden Key. On this occasion Rubens painted portraits of the King, Queen and all the Princes. Whence, returning to Flanders, it is said he took with him thirty thousand scudi.

Arriving in his native country laden with riches and honours, he was made Secretary and Counsellor of State, and bought various estates, where he lived in a grand fashion. The more talent can accomplish the more its value is appreciated.

Then full of worldly happiness, he departed this life in the year 1640 to enjoy the bliss of Paradise. He died in his home town of Antwerp with great fame and with the deferential applause of all the virtuosi and citizens. He left behind children who now enjoy the reputation and grandeur of being his family. Thus Rubens' talent and worth have ennobled painting and honoured his native country.

# JOACHIM VON SANDRART

*The Life of*
*Peter Paul Rubens,*
*Painter*

**from**

*Teutsche Academie*

1675

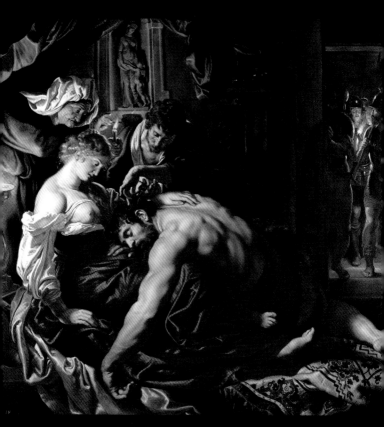

*Samson and Delilah, c. 1609, painted for the Burgomaster of Antwerp*

It is known worldwide that for a hundred years and more the celebrated Netherlandish city of Antwerp, before all other cities in the world, has had the fame, praise and glory of educating and bringing forth ingenious spirits in the noble art of painting. Not even Rome can vie with her, for almost all who painted there and left behind praiseworthy works were foreigners who came from Urbino, Florence, Venice or, most frequently, Bologna. Therefore Antwerp may prize and esteem herself highly.

Among those who originated in Antwerp also was Peter Paul Rubens, the excellent artist who was born of distinguished parents on the 28th of June 1577. After he was educated in all disciplines required of a youth, and after he showed remarkable ingenuity, intelligence and intellect, his teachers recommended him for the law, which pleased his parents greatly. But there always glimmered inside him a desire for the noble art of painting, by means of which he produced diverse, magnificent drawings. This convinced his parents to apprentice him to Tobias Verhaeght, then a celebrated painter of Antwerp, to learn the noble art. After this first beginning, they sent him to Octavio van Veen, for he, Rubens, distinguished himself so greatly in these early years that many admired

him for his beautiful spirit. He rapidly mastered all required rules and, owing to his outstanding intellect, advanced his good reputation so that Archduke Albert of Austria, the then gracious regent of the land [Spanish Netherlands], took him into his service and had many spirited works made for him.* Later Albert also sent him to the Duke of Mantua in Italy in order for him to see there in the duke's palace the most extraordinary paintings and statues (unsurpassed in Europe at the time) and to perfect his art from these examples. He made judicious use of these, making them the object of all his studies, but in the Venetian manner which suited him best.

Hereafter Rubens made his way to Rome where he diligently contemplated the praiseworthy statues of antiquity, as well as the works of Michelangelo, Leonardo da Vinci, Raphael of Urbino and others, always bearing in mind that the aforementioned Venetian manner suited him better. There he painted two altar panels for the Duke of Mantua, one with standing male saints, the other filled with female saints, the whole life size, as can still be seen in Rome

* Rubens was not appointed court artist until 1609, but may have had some connection before then. He probably went to Italy on his own initiative, and in Mantua he was appointed court artist.

in the Chiesa Nuova next to the high altar.[1] At the same time and in the same city Rubens executed in a remarkable manner a crucifixion of Christ whose hands are securely nailed to the cross while his feet fall in an unencumbered and free way. The picture is moreover painted with many figures in a vigorous and spirited style and now serves as altar panel in the same city in the little church of Santa Croce in Gerusalemme.[2]

After happily improving himself by collecting for others and for himself diverse curiosities which served his studies, Rubens lost no time in moving to Mantua where he hoped to be of better use; then via Venice back to Archduke Albert in his home country where he settled and was highly regarded by everyone because of his refined manner of speaking, his diverse languages and polite demeanour. All the more so because just then all of the Netherlands,

1. These paintings were commissioned in 1606 on Rubens' second visit to Rome by the Oratorians of the Chiesa Nuova, not by the Duke of Mantua, to whom the rejected panel (now Musée des Beaux Arts, Grenoble, ill. p. 10) was however offered. The replacements, ill. pp. 28-29, are still in situ. See Introduction, pp. 9-11.
2. 1601-2. Part of a group of three paintings commissioned by Archduke Albert, now in the chapel of the municipal hospital, Grasse, although the *Crucifixion* is a later copy.

under the shade of peace, was filled with prosperity and infected with the love of art, which almost nobody could satisfy, partly because local artists had neither the talent nor the knowledge to paint large figures, partly because they were too sullen for such work and preferred to pursue their appetite for leisurely walks and social gatherings than to work. Whereas he, Rubens, by nature very different, socialised only with the most noble of the city, worked with expedience and industry, was polite and friendly with everyone, pleasant and popular and of great use in his profession. Furthermore, he made an excellent marriage by which he increased his fortune more and more. As his reputation resounded by and by through all of upper and lower Germany [Germany and the Netherlands], not only princes demanded some of his works but also almost every connoisseur in the Netherlands wanted something created by his hand, which is still honoured and preserved by his descendants.

Rubens strove for his inventions to be exceptionally graceful, effective and joyful, his drawing delicate, the palette beautiful to the eye and full of pleasing colours, as witnessed by innumerable engravings

*Opposite: The Holy Family with Sts John and Elizabeth, 1614-15; painted for the private oratory of Archduke Albert*

after his works, of which, for the sake of brevity, I want to advise the favoured reader. Taking into account only his most famous works, he painted, among others, for the king of France the gallery in the Luxembourg Palace in Paris, with scenes from the life of King Henry IV and his wife, Marie de' Medici,[1] in an allegorical, poetic and generally profound manner, thus receiving in a short while great praise and rich compensation. Afterwards he executed many great works for the king of Spain and other noblemen, earning him no less fame, so that his name was on everyone's lips.

Meanwhile Rubens' wife fell ill and without deriving any benefit from medicines, succumbed quickly. In order to forget his sorrows, he travelled to Holland to visit there the many and excellent painters of whom he had heard and whose works he had seen. Thus he also came to Gerrit Van Honthorst in

1. The canvases for the Luxembourg Palace were commissioned in 1621 by Marie de' Medici, not Henry IV, who was assassinated in 1610. They consist of scenes from the lives of Henry and Marie, but only the latter were finished; they are now in the Louvre, though sadly no longer in the magnificent setting commissioned by Napoleon III. Some preparatory paintings for the series depicting Henry IV also survive.

*Opposite: The Meeting of Marie de' Medici and Henry IV at Lyons, 1621-25*

Utrecht who received him civilly and showed him what was available in the studio, among others a Diogenes with a lantern in his hand to look for men in broad daylight in the crowded market at Athens.[1] Though Rubens was well-pleased with the invention, he saw immediately that this could have been done only by a young painter, of whom there were many in the room. When he desired to learn who had begun this Diogenes, Honthorst answered: 'This young German,' and pointed at me. Speaking approvingly of such beginning, Rubens encouraged me to further reflection and diligence, whereupon he examined everything else with full satisfaction. When he wished to visit Abraham Bloemart, Cornelis Poelenburgh and others, and Honthorst was prevented from accompanying him because of a slight indisposition, he desired for me to be sent with him, whereupon I showed him everything to his great satisfaction. Honthorst held a banquet in his honour, and Rubens afterwards travelled first to Amsterdam and other places in Holland where, within fourteen days, he saw everything that was praiseworthy. Being an artist who in my profession could greatly enhance my knowledge through conversation, advice, words and deeds, I served him willingly and accompanied

1. Lost

him to the Brabant border. Being able to report much of this journey and Rubens' virtuous conduct, I learned that, as far as he was excellent in his art, I also found him perfect in all other virtues, and I further observed that he was highly esteemed by persons of the most exalted as well as the most humble rank. Among others he highly praised on this journey Van Honthorst's perfect manner of painting, especially night pieces; Bloemaert's noble draughtsmanship and Poelenburgh's well-proportioned small figures which were accompanied in Raphael's manner by delicate landscapes, ruins, animals and some such, and of which Rubens commissioned several examples.

Afterwards Rubens executed many great works for the king of England, Charles Stuart, and the Duke of Buckingham,[1] as one can see in Banqueting House and York House. In order to speed up the execution of such large works he employed many young people whom he trained competently, each one according to his best inclination and ability. They helped him

1. Rubens painted *The Glorification of the Duke of Buckingham* (destroyed) and a large allegorical equestrian portrait (destroyed, oil sketch ill. p. 80) before 1627. The ceiling canvases glorifying the rule of James I were painted for the Banqueting Hall in 1631-34 and are still in situ (see oil sketch ill. overleaf).

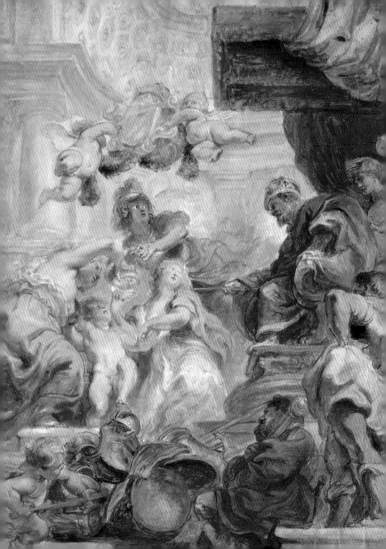

considerably because they painted mostly animals, birds, fish, landscapes, trees, brooks, earth, air, water and forests. Rubens always made a model of his inventions of two or three spannen high, from which one of his pupils, such as Anthony Van Dyck, Jacob Jordaens, Jan van den Hoecke or others painted the large canvas, which he later touched up or of which he completed the most important parts himself.* Thus he created a great advantage for himself and incomparable benefits for the young men who were properly trained in all aspects of art. Through his industriousness the city of Antwerp became an exceptional art school in which students achieved notable perfection.

After this Rubens married a second time, to the maiden Simente [Helena Fourment] who in her time earned the highest praise for her virtue, wealth and beauty. Through this marriage he acquired a large family and many relatives and friends. He also built himself a very comfortable, beautiful house which contained, next to the garden, a 'Kunstkammer' in the

* The average height of the sketches is 40-60 cm. Only van den Hoecke was a pupil in the sense of an apprentice.

*Opposite: James I unites the Kingdoms of England and Scotland, c. 1630, oil sketch for ceiling painting in the Banqueting Hall, London*

shape of a rotunda with light falling from above, which illuminated to great advantage all the rare and orderly arranged paintings and statues within it, by his own hand as well as by other noble artists, besides several curiosities. It was his habit to take visiting art lovers there, which is why the Duke of Buckingham, in order to fill his palace quickly with art objects, demanded such pieces and arranged to have them purchased for sixty thousand Netherlandish guilders through the skilful Michel le Blon of Amsterdam, who was the true Mæcenas of all virtue. From this it becomes clear that Rubens was well able to gain benefits not only from his own art but also from other arts and from his dealings, and thus knew well how to pave the way to riches. Once the world-famous alchemist Master Brendel from London, highly honoured by everyone, visited him and boasted how he had nearly succeeded in discovering the proper tincture so that in a short time a sure way to make gold could be found. If Rubens would furnish a house for him and in the meantime advance him the necessary expenses, he, Master Brendel, would remain in Rubens' company, whereupon Rubens answered: 'Master Brendlin [sic], you are come only twenty years too late, because in that time, through the brush and paint, I found the true Lapis Philosophicus [the philosopher's stone].'

At another time, the artful Antwerp history painter Abraham Janssen, whose lethargy and other bad habits were damaging to his fortune, observed that Rubens, on account of his skilfulness, ascended splendidly. He intended to hinder such reputation and challenged him to a painting competition. Those who recognize the truth should judge which of the two pieces was superior. Meanwhile Janssen had certain hopes, because Rubens mostly painted from the mind, whereas he painted from life with good care and over a long time. Because of his great truthfulness to nature and the strength of his colours, he would easily defeat the work of the other. But Rubens completely rejected Janssen's suggestion and said that he did not want to start painting because of a competition, but that he had always been in the habit of painting, and wanted to continue that way in future, whereas he, Janssen, should keep to his own manner.

Among other great honours accorded to this artist, the king of Spain [Philip IV] sent him in certain matters of state to King Charles Stuart in England. However, when King Charles recognized

*Overleaf: Minerva protects Pax from Mars ('Peace and War'), 1629-30. Probably painted in England while Rubens was trying to negotiate peace between Spain and England, and presented by him to Charles I*

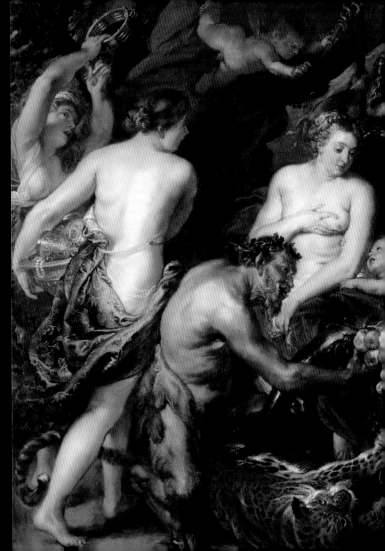

what the concerns were, and that his intentions were completely different, he reversed the plan under the pretext that it was the custom to accept only princes and dukes as envoys, although the person Rubens, beyond these political affairs, was very dear and agreeable to him, wherefore he received Rubens very graciously as a private person and made this occasion very beneficial to him, for the purchase of the noble works for the Banqueting House had been concluded shortly before. These soon were sent from Antwerp to the great satisfaction of the king.

When Rubens was in Spain he painted portraits, among others, of King Philip, the queen and the Duke of Olivares, which were later engraved in copper by Paulus Pontius and Lucas Vorsterman. He also copied many great works in the Escorial which were pieces painted by Titian and brought them with him to the Netherlands.[1] Meanwhile it had become widely known there that Rubens had been in Spain on the order of the Infanta Isabella as the regent of

---

1. Three of these copies survive: *Venus and Cupid with a Mirror*, 1606-11, Madrid, Museo Thyssen-Bornemisza; *The Rape of Europa*, 1628-29, Madrid, Prado; and *Diana and Callisto*, 1630-35, Knowsley Hall, Lancashire.

*Opposite: Elisabeth Bourbon, queen of Spain, 1636-37*

the Netherlands, to introduce the king to what was then the bad situation of the Spanish Netherlands, as actually one place after the other fell into Dutch hands, so that his majesty could strive for measures to bring the situation on a better footing. Consequently, the king's answer, together with many other secrets, was entrusted to him. Upon Rubens' return he was visited in Antwerp by one of the country's most noble princes, who was suspected of unjust dealings against the king. He secretly aspired to find out from Rubens whatever would serve him in his cause. But because Rubens was determined to keep everything to himself until death, this prince became so angry that he cast around menacing words. These threats, together with this gentleman's great authority in matters of state and that everything had the appearance of becoming worse over time, gave Rubens reason to completely remove himself from all matters of state and to spend his time in solitude with his muses. From this one can infer his intelligent mind, by which guidance he made himself scarce in good time, for soon afterwards many like him were drafted, ruined and overthrown.

At the same time the city of Antwerp was struck by great damage because of the absence of Spanish and Indian fleets which were taken by the enemies,

so that the cashing in of the bills of exchange in the Netherlands did not take place, whereby great hardship arose among the creditors who had advanced money. This resulted in many bankruptcies in Antwerp so that almost no one remained without great damage except Rubens, who, favoured by fortune, came away without any damage and misfortune although he had invested great amounts of cash in bills of exchange. With such storms hovering everywhere in the air, Rubens stayed with his studies at home in great solitude, worked steadily and collected meanwhile, by his own hand as well as others, a great number of paintings, drawings, statues and ivory sculptures, the latter mostly by the diligent imitation of Rubens' work of our praiseworthy Petel from Augsburg, so that one has to wonder at such great expense because he was not normally a spendthrift, indeed he was often accused here of holding onto cash rather too tightly. But it came to light soon after his passing what his aim had been, in so far as his disposition went that everything in the form of drawings, engravings and such that would be pleasant and useful in the study of art should be left to one or the other of his sons who would enjoy practicing art, or failing that, to the husbands of the daughters who were thus inclined. The rest should be sold at

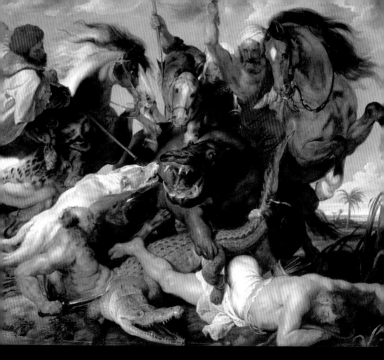

*Hippopotamus and Crocodile Hunt, 1615-16*

public auction, as indeed it was done shortly after his death on a set day in his house to the one who offered the most in cash, as is the custom of the country. This same sale was valued so highly because everyone wanted something from Rubens' cabinet that it produced an unbelievable sum of money.

After his first manner brought from Italy, Rubens strove diligently to imitate the strength of Caravaggio's colouring, whose hand he observed closely. However, because this colouring was too difficult and slow to achieve, he later made use of a quicker and easier manner, as in our Germany it is demonstrated in his large bacchanals at the imperial court in Vienna,[1] also at Schleissheim, in the Bavarian Electoral rooms, an unusual, richly significant hunt of barbarians on horseback against the wild lion,[2] which was also executed in copper, also a cruel hunt against monstrous crocodiles.[3] Rubens' manner is demonstrated no less in the high altar together with two side altars in Neuburg on the

1. The only surviving painting that corresponds is *The Feast of Venus*, 1636-37, Kunsthistorisches Museum, Vienna, ill. overleaf
2. 1615-17, destroyed, but known in an engraving by Pieter Soutman
3. 1615-16, Alte Pinakothek, Munich, ill. opposite

*Overleaf: The Feast of Venus, 1636-37*

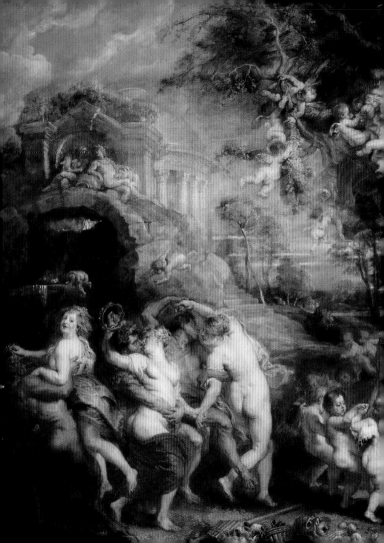

Danube, of which the first shows the intercession of our Lady with Christ or rather the Last Judgment, the others the birth of Christ and Pentecost.[1] At Hemau in the Neuburg [Upper] Palatinate, His Highest Princely Serene Highness has presented at the high altar from Rubens' hand how St Michael hurls down Lucifer, very excellent and highly esteemed.[2] Rubens' manner can be appreciated also at Freising where the high altar presents from St John's Apocalypse, ch. 12, how the dragon wants to swallow the newborn little child, but is conquered by the archangel Michael, everything of very spirited invention and very joyfully coloured and pleasant to the eyes.[3] At Augsburg, in the church of the Holy Cross, one sees the Assumption of the Virgin.[4] I also have by his hand a Herodias with her daughter, who carries to her father the head of John the Baptist on a dish,[5] a work that, because it was praised by all art lovers, I have bought from the Milich cabinet and

---

1. The *'Great' Last Judgment*, Alte Pinakothek, Munich; *The Adoration of the Shepherds* and *The Descent of the Holy Spirit*, Staatsgalerie, Neuburg, all 1614-17   2. *St Michael Striking down the Rebellious Angels*, 1621-22, Alte Pinakothek, Munich   3. *The Woman of the Apocalypse*, 1623-24, Alte Pinakothek, Munich; oil sketch in the J. Paul Getty Museum, Los Angeles   4. In situ   5. Probably a version of the painting now in the National Gallery of Scotland, Edinburgh

placed among my other rare pieces. I also own the myth of Nessus and Deianeira by Rubens' most fortunate hand; but also a certain soldier in armour who has caught and clasps in his embrace a voluptuous woman who tries to escape; there is an old woman next to him, in half-length figures, life-size, depicted with wonderful art.[1]

There would be no end if all works were to be described that this spirited and profound artist produced, whereby, besides [applying] his orderly and artful mind, he proceeded with his hand masterfully and quickly, so that he finished his works before others began, until finally his hands were disturbed by gout so that he had to give up large works and content himself with relatively small pieces, sacred as well as profane, and landscapes. Such messengers of death served him to create order in all his affairs, and after he accomplished this according to his wish, he passed away adorned with the beautiful laurel wreath of undying praise, and was laid to rest in the most dignified manner. Before him was carried on a black velvet cushion a golden crown, and the body was

1. This sentence was added to the Latin edition (1683) of Sandrart's *Life*. The *Nesssus* may be a version of a painting in Hanover. The painting with the soldier is perhaps the *Switzer and his Mistress* (also known as *Mars and Venus*), Palazzo Bianco, Genoa

accompanied to its resting place by the most distressed art lovers. His name however will blossom as long as the world lives, and busy Fame will trumpet his virtue to all four corners of the world. He died on the 30th of May in his sixty-third year in the year of Our Lord 1640.

# ROGER DE PILES

*The Life of Rubens*

**from**

*Dissertation sur les ouvrages*
*des plus fameux peintres,*
*avec la vie de Rubens*

1681

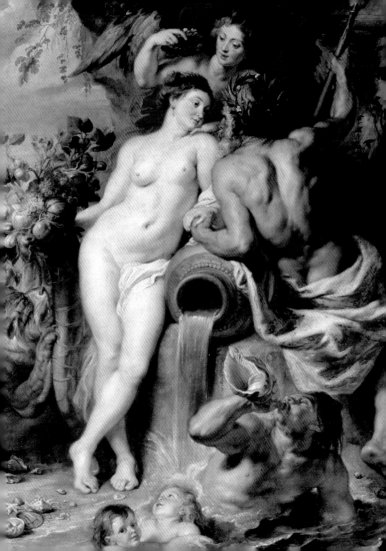

Rubens' country of origin is apparently disputed, just as Homer's was in the past. The city of Antwerp suffers with difficulty any attempt on its title; and those who have written the Life of this excellent man claim that this was the place of his birth. Meanwhile, the city of Cologne prides itself and finds its glory in having given him the light of day. Both the one and the other have their reasons. What follows is the truth of the matter as regards Rubens; I have taken care to inform myself about it precisely and am going to relate the facts in few words and in all faithfulness.

Peter Paul Rubens had as a father Jan Rubens of the city of Antwerp, who combined nobility of birth with solid virtue and profound erudition. Having spent six years in the different states of Italy in order to fashion his taste for good things and to fortify his judgement, he resolved to enter the law. Having taken his doctorate in civil and canon law at Padua he returned to Flanders where he acquitted himself with dignity as a Councillor in the Senate of Antwerp. For six years he served the public happily in this capacity when civil war forced him to leave his homeland (attachment to which he so well deserved

*Opposite: The Union of Earth and Water (Antwerp and the Scheldt), c. 1618*

by service to the public good) and go to live in Cologne, to which his great love of peace had led him to retire with his family.

It was there in 1577 that our Peter Paul Rubens was born. And it was there that he learned the rudiments of grammar and literature, which he did with such predilection and facility that very shortly he surpassed his contemporaries. Thus he progressed, doing things in advance of his age, when his father died in 1587, forcing his mother to return to Antwerp where Rubens finished the course of his studies with distinction (though at a relatively tender age).

No sooner had he left school than his mother placed him as a page with the Dowager Countess of Lalaing, but not having been able to adapt himself to the daily life of grandees he did not remain long. Moreover, unable longer to resist the forceful impulse of his genius which drove him to a love of painting, he obtained permission from his mother that, in the absence of the greater part of the family fortune, lost in the wars, he would go and learn to draw in the studio of a painter from Antwerp, Adam van Noort. He spent several years there establishing the first foundations of his art which he did with such success that it was clearly evident that nature's intention in forming him had been to make a great painter.

He later spent four years under the tutelage of Otto van Veen, painter to Archduke Albert, and at that time the Apelles of the Flemish nation. A mutual passion for letters having united the two in friendship, this master forgot nothing that he had learned in order to communicate it to his disciple; he revealed without restriction all the secrets of his art and taught him above all how to arrange his figures and how to distribute light to advantage. At last, having brought him forward in so short a time, and the reputation of this illustrious disciple having risen to such a point that doubt was created about which was the most able, he or his master, Rubens decided to go to Italy to see the most beautiful works of the ancients and moderns, to meditate upon them, to copy them, and to make his brush commensurate with what he would find most beautiful there, and most closely approaching Nature.

He left on the 9th of May in the year 1600 and on arriving at Venice he took lodgings by chance with a gentleman in the retinue of the Duke of Mantua. Having been shown some of his works, this gentleman showed them in turn to the Duke, his master, who, being a passionate devotee of all the arts, and particularly that of painting, pampered Rubens with a hundred caresses, promised him his friendship, and

tried by every means to persuade him to come and stay with him. Rubens was glad to oblige, delighted with such a fine opportunity to see, examine and study the works of Giulio Romano, about whom he had conceived great ideas.

While Rubens stayed at Mantua, he received so much notice from the Duke that during the seven years of his stay in Italy he styled himself as one of the latter's gentlemen as a matter of pride. Having paid his dues to this prince over a considerable period of time, he then went to Rome where he painted three pictures for the church of Santa Croce in Gerusalemme on behalf of the Archduke Albert of Austria, the church from which the Archduke had formerly held his cardinal's hat and where he had had the chapel of St Helena, in which these three paintings hang, restored. The altarpiece, at the centre, represents the saint holding the True Cross and the others on the two sides, a crown of thorns and a crucifix respectively.[1]

Shortly thereafter he was sent by the Duke of Mantua to Spain to present a magnificent carriage

1. Chapel of the municipal hospital, Grasse

*Opposite: Archduke Albert VII, c. 1618, when Rubens' longstanding patron was sovereign of the Netherlands*

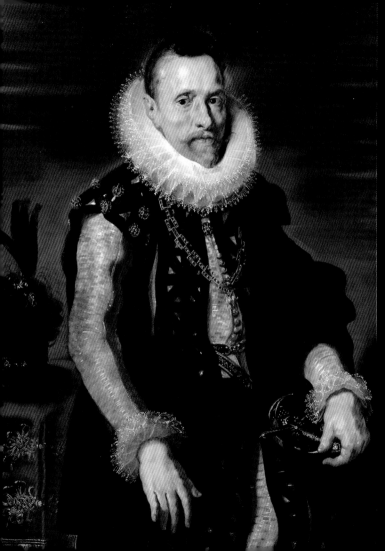

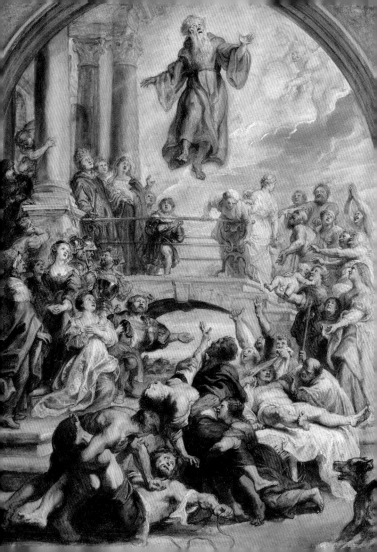

and seven horses of extraordinary beauty to the King. He had no sooner returned from this journey than he made another, to Venice, with the idea of examining in depth and contemplating at leisure the beautiful things that he had only looked at in passing and whose great number had erased all memory of them from his mind; for, he had only looked at them long enough to learn to appreciate them and to form an ardent desire to see them again some day, and to satisfy fully the passion he had to learn. And indeed, he drew from the works of Titian, Paolo Veronese, and Tintoretto all the benefit that one can draw, and thereby embellished his manner.

Having thus fortified himself at Venice, as much by reflecting on the works of the great masters as by copying them, he returned to Rome where he was chosen to paint the principal pictures for the Chiesa Nuova of the Priests of the Oratory which had just been completed. One is at the main altar, the other two at the sides.[1] For the one in the middle he painted the Virgin holding the Infant Christ surrounded by angels in different attitudes of adoration. The two

1. All still in situ; reproduced on pp. 28-29. See introduction.

*Opposite: The Miracles of St Francis of Paola, 1628, oil sketch; a development of the composition of Titian's Assumption, which Rubens saw in Venice*

side paintings represent several saints standing, among others Pope Gregory and St Maurus dressed as a soldier; painted in the manner of Paolo Veronese; these figures display great nobility. The sketches of these three paintings are today in the abbey of Saint Michael at Antwerp where Rubens deposited them on his return to Flanders.[1]

Of all the towns in Italy visited by Rubens, Genoa was the one in which he stayed the longest, either because he found the climate gentler, or because he received more compliments there than elsewhere, or finally because he found better occasion there to display what he had learned and to exercise his natural talent for painting, for one sees many of his works there and they are valued as highly as anywhere else on earth. The majority of gentlemen wanted a work by his hand, and the Jesuit church cherishes two of his paintings, of which one is a Circumcision and the other a St Ignatius curing the sick.[2]

Rubens had been in Italy seven years when news that a dangerous illness had struck his mother made

---

1. In situ   2. In situ but dating from later than implied by de Piles; see oil sketch reproduced opposite

*Opposite: St Ignatius curing the Sick, c. 1619, oil sketch for altarpiece in Genoa*

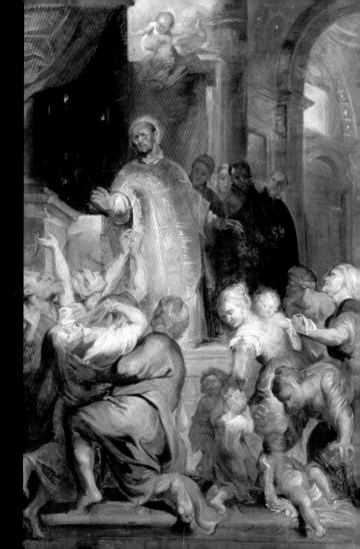

him return to Flanders; but though he travelled post in order to get there the sooner, he arrived to find his mother dead.

Having thus arrived in his own country in 1609, and news of his expertise and merit having spread, the Archduke Albert and the Infanta Isabella, his wife, determined to have their portraits painted by his hand and, fearing that he would return to Italy, they made him many gifts and, by granting him a pension and by all manner of other proper means, sought to attach him to their persons. Seeing himself thus caught by such powerful connections, he thought it appropriate to engage in those of marriage: he married the daughter of Jan Brant, a councillor of the Senate of Antwerp, and of Claire de Moï, whose sister had married his elder brother, Philip Rubens, Secretary to the Senate of the city of Antwerp.

The Princes, who then constituted the Court of Brussels, did everything they could to oblige Rubens to live there because of the pleasure they took in his company; and though he had great difficulty in resisting them, he managed so well that he obtained permission to establish himself at Antwerp and made it his usual dwelling place, for fear that affairs of

*Opposite: Isabella Brant, c. 1620-25*

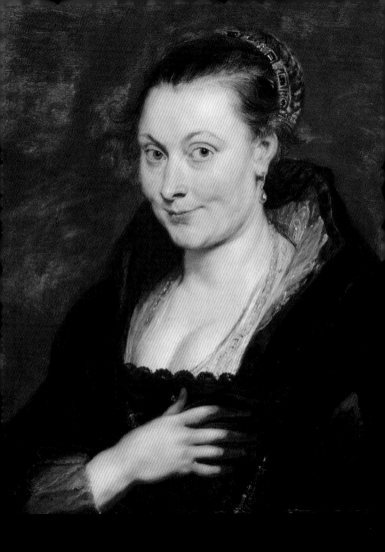

court, in which one thing leads to another, should prevent him from attending to his studies in painting and from acquiring in that art all the perfection of which he felt himself capable.

He therefore bought a large house at Antwerp. He rebuilt it *à la romaine* and decorated the interiors, making them suitable for a great painter and a great amateur of beautiful things. This house was graced with a spacious garden in which he planted, for his own interest, all the kinds of trees that he was able to collect. Between the courtyard and the garden he had built a rotunda, like the Pantheon in Rome, in which the light enters from a single opening from above in the centre of the dome. This room was filled with busts, antique statues and paintings that he had brought back from Italy, and other rare and very curious things. Everything was placed there according to order and symmetry, which is why anything that merited but could not find a place there was used to decorate the rooms in the apartments of the house.

He had so great a love of everything of antique character that he had bought on his own account a prodigious number of statues, medals and precious engraved gems from all over Italy. And it was in contemplation of these beautiful things that he spent the time he had for rest.

Prince Albert had for Rubens a very special affection and wanted to hold at the baptismal font his eldest son to whom he gave his name.

After the death of this prince, Rubens entered with no more difficulty into the esteem and good graces of the Princess his widow, and of all the greatest grandees of the court, notably the Marquis Spinola who took pleasure in often talking to Rubens, and in repeating that he saw so many fine talents shining in the soul of this great man that he believed painting to be one of the least.

It was around this time that Queen Marie de' Medici was having her Luxembourg Palace built. In order to render it perfect in every way she wished to decorate the two galleries with works by Rubens, having him paint her life in one and in the other the actions of Henri IV. But only half her plan was realised because she was exiled at the moment Rubens was making eternal the great actions of her husband the King, the painter having started with the history of the life of this great Queen, of which he left a work of perfection as an eternal monument to his science.[1]

1. Paris, Louvre; see note p. 42, ills. pp. 4, 43, and overleaf

*Overleaf: The Apotheosis of Henry IV and Proclamation of the Regency, 1621-22, oil sketch*

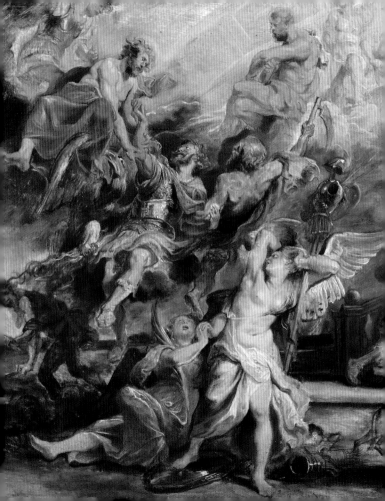

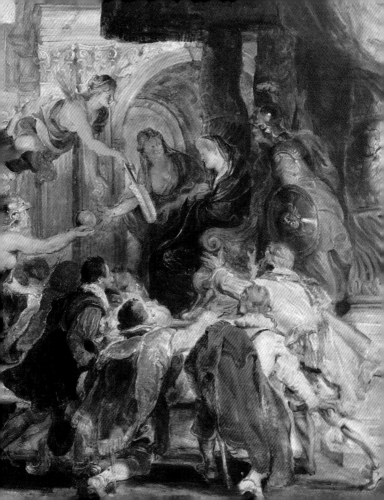

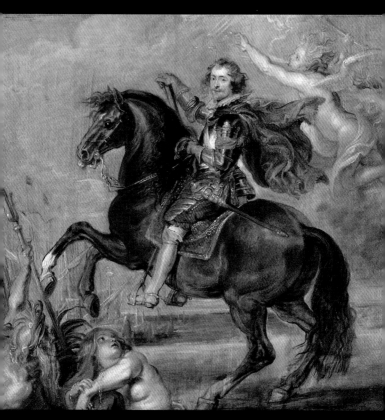

*The Duke of Buckingham, before 1627,*
*oil sketch for lost portrait*

During the trip that Rubens made to Paris in order to install the paintings and to give them their finishing touches (which occurred in 1625) he met by chance in that city the Duke of Buckingham who stood in high esteem with the King of England and the princes of the French Court. Buckingham knew of Rubens' merit and since he had important matters to discuss with him he begged him to paint his portrait. The painter acquitted himself perfectly, and exceeded the Duke's expectations in all respects. After having conversed for some time and having established a close friendship, the Duke confided in him the pain he suffered at the misunderstanding and the conflict between the crowns of Spain and England, and of his ambition to assuage them.

On returning to Brussels Rubens conveyed the matter to the Infanta who commanded him to maintain this friendship with the Duke as assiduously as he was able. He succeeded in this so perfectly that the Duke of Buckingham, supposing that Rubens was about to enter into affairs of state and that these great matters would partly diminish his great love of painting, a little while later sent one of his servants to Antwerp to offer Rubens one hundred thousand florins for his antiquities and the greater part of his pictures, with instructions to do whatever necessary

to persuade him to part with them. Rubens easily discerned the Duke's passion for beautiful things and allowed himself to be conquered by his desire to satisfy it, on condition, however, that to console himself for the loss of his cabinet, into which he had put all his love and which had cost him all his care, he would have casts made of the marble statues that he was giving up and by this means fill the spaces of the originals. As for the places occupied by the paintings he had sold, he decorated them with his own works.

Meanwhile, in 1628 the courts of Spain and England were considering peace and the Marquis Spinola, who was perfectly aware of Rubens' merit, came simultaneously to the conviction that there was no one better than he to broker it. He spoke to the Infanta, who strongly approved his idea, and who sent Rubens on a mission to the King of Spain with the express purpose of proposing some means of achieving peace, and of receiving the King's instructions in return. The King was so pleased with Rubens, and found him so worthy of the task for which he had been sent that, in order to lend greater lustre to his merit, he made him his knight and gave him the charge of Secretary to his private Council, for which he dispatched to him letters of appointment and to his son Albert by order of succession.

During the time that Rubens remained in Spain the King had him make copies of several of Titian's finest paintings at Madrid, among them the *Rape of Europa*[1] and the *Bath of Diana*,[2] with the idea of giving the originals to the Prince of Wales who had expressed a great desire for them. That Prince was at the Court of Spain to marry the Infanta, but since the engagement was not concluded the copies remained at Madrid along with the originals.

The following year Rubens returned to Brussels to tell the Infanta what he had accomplished, and to convey to her the proposals with which he was charged by the King, her nephew. He then travelled to England with commissions from the Catholic King and the Infanta to negotiate this great event. There the King, a great lover of painting, received him at London with particular honour, and paid him many compliments. Chancellor Cottington was appointed to receive his proposals and examine them. After having concluded the peace at the behest of the people, and to the satisfaction of the two Kings, Rubens took leave of the King of England who, in order to give him marks of his gratitude before he left, made him his knight in the same way

1. 1628-29, Prado, Madrid  2. 1630-35, Knowsley Hall, Lancashire

that the Catholic King had done in Spain. To his coat of arms he added a canton charged with a lion, and at Whitehall the King drew the sword that he had at his side and gave it to Rubens, to whom he also gave a precious diamond that he took from his finger, and a hatband also of diamonds worth ten thousand crowns.

Covered with all these honours, Rubens, having returned to Spain to give account of his negotiations, was received at the Spanish Court with all possible tokens of esteem, confidence and friendship. The King appointed him one of the Gentlemen of his Chamber and honoured him with the Golden Key; and in return for having painted the portraits of the Royal family, their Majesties added a substantial fortune to the honours that they had paid him.

Rubens, having gloriously fulfilled his great work of peace, and having returned to Antwerp covered in honour and wealth, married for the second time in 1630, after four years of widowerhood, taking as his bride Helena Fourment, only sixteen years of age and an extraordinary beauty. He had five children

*Opposite: Helena Fourment in a Fur Wrap, c. 1636-38. Rubens called this painting 'The Little Fur Coat' and left it to Helena in his will*

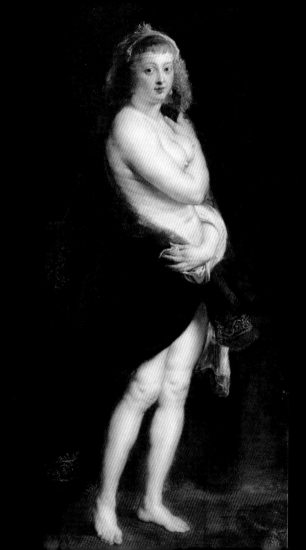

by this woman of which the eldest is a Councillor at the Parliament of Brabant.

I am not going to stop to give a detailed account of Rubens' works: the number of them is almost infinite, as one can see from the prodigious quantity of prints engraved after them. I will only say that in addition to the various pictures that he made on all sides, and for all the courts in Europe, for the Emperor, for the Kings of Spain, England and Poland, for the Dukes of Bavaria and Neuburg, and for several other princes, he has filled almost all the churches in Flanders with his paintings, notably those of Our Lady of Antwerp, the churches of the Premonstrez, the Cordeliers, the Jacobins, the Augustinians and, among others, the Jesuits, for whom he even painted ceilings. The hall in which the King of England gives audiences to ambassadors is decorated with nine large paintings by his hand: they represent the great actions of King James after his entry to England having secured himself the Kingdom of Scotland.[1] In Spain, in the Palazzo del Tore della Parada, three leagues from Madrid, one can see many paintings whose subject are taken from Ovid's *Metamorphoses,* whose dimensions the King

1. In situ; oil sketch ill. p. 46

had Rubens take whilst he was at court in order that he might work on them at his leisure, and once he had returned home.[1] And since these paintings are arranged in such a way that there is a lot of space between them, Snyders has filled the voids with animal pictures.

If to live in peace means undertaking only those things for which nature has given one particular talents and the assurance of success in carrying them out, then one can say that Rubens led the happiest life in the world. He was born with all the advantages that make a great painter and a great politician. If at Antwerp he left his painting at which he excelled with unbelievable love and facility, it was to go to the Court at Brussels, to which the Infanta frequently called him for affairs of state, ones which he directed as far as he was able to the succour of the people and to the restoration of the fine arts. And as the war between Spain and Holland was a great obstacle to these two ends he explained several times to the Infanta the reasons that should induce her to make peace; an outcome that the princess desired passionately. She entrusted Rubens with secretly conducting

1. These paintings, most of which are now lost, were almost entirely executed by assistants

the negotiations which would easily have been fulfilled by the care of this excellent man, had the mission not been diverted by those envious of his glory.

He was involved in several other matters on behalf of the Infanta, mainly at Brussels with Queen Marie de' Medici and Gaston of France, Duke of Orleans, with Ladislas, Prince of Poland, with the Duke of Neuburg, and other princes of Europe, whose affection he had gained by his eloquence and his other fine qualities.

The talent he had for the handling of affairs of state made them easy, and they provided a rest for him rather than a serious and tiresome occupation. And just as he left painting only for matters of state, so he left affairs of state only for painting, which was the greatest charm of his heart.

The virtues that he had acquired and all the fine qualities with which nature had blessed him made him pleasing to everyone. He was tall, his bearing majestic, the turn of his countenance regular, his cheeks ruddy, his hair chestnut brown, his eyes brilliant with tempered fire, his air happy, gentle and polite. His manner was engaging, his mood obliging, his conversation easy, his mind lively and perceptive, his speech measured and the tone of his voice agreeable, and all this made him naturally eloquent and

persuasive. When painting he conversed without difficulty; and without interrupting his work he spoke easily to those who came to see him. Queen Marie de' Medici took such pleasure in his conversation that throughout the time that he worked on the two cycles of painting that he made in Paris, those in the Luxembourg gallery, Her Majesty was constantly behind him, charmed equally by hearing him speak and watching him paint. One day she wanted him to see her circle in order that he should judge the beauty of the ladies of the Court; having looked at them all closely, 'This one must be Madame, the Princess of Guéméné,' said he, picking out the most beautiful. It was indeed; and when M. Botru asked him whether he was acquainted with her he answered that he had never had the honour of seeing her before and that he had acknowledged her only from the account he had been given of the Princess's beauty. He formed friendships only with those of merit and entered into conversation only with learned and high minded people who often came to talk about science or politics.

He kept up an important correspondence with several Lords, mainly from the Spanish Court: with the favourite, Duke Olivares, Prime Minister to His Catholic Majesty; with the Marquis de Leganès, the

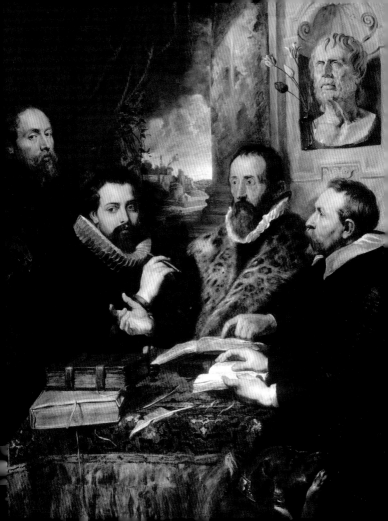

Marquis Spinola, and several others. This is clearly evident from the letters found among his papers, of which the majority are in code and which his descendants preserve today.

Though the life that Rubens led may have appeared dissipated it was, in fact, very disciplined. He rose everyday at four in the morning and made it a rule to start the day with Mass, unless he was prevented by gout by which he was greatly bothered. After Mass he went to work, having always with him and at his employ a reader who read to him aloud from some good book, usually by Plutarch, Livy or Seneca.

Because he took great pleasure in his work, he lived in such a manner as to be able to work easily and without troubling his health. It is for that reason that he ate very little at lunchtime, for fear that the smell of meat should prevent him from working, and conversely, that getting down to work would prevent the digestion of the meat consumed. He worked in this manner until five in the evening when he mounted a horse and set off out of the town or around the

*Opposite: The Four Philosophers, 1611-12. Self-portrait (left) with his brother Philip (centre left), the humanist Justus Lipsius (centre right), both deceased when Rubens painted the group, and the lawyer Johannes Woverius (right), with Lipsius' dog Mopsus, under a bust of Seneca*

ramparts in order to take the air, or he did something else to relax his mind.

On returning from his outing he usually found at home one of his friends who had come to dine with him and to contribute to the pleasures of the table. However, he had a great aversion to excesses of wine and good food, as well as to gambling. His greatest pleasure lay in exhibiting some beautiful Spanish horse, in reading a book, or in looking at and contemplating his medals, his agates, his cornelians and other engraved gems, of which he had a beautiful collection that today is in the cabinet of the King of Spain. As he always painted from nature and as he frequently had occasion to paint horses, he had in his stable some of the most beautiful and proper for painting.

Though he was greatly attached to his art he nevertheless organised his time in such a way that he always devoted some part of it to the study of letters, that is to say, to ancient history and to the Latin poets which he understood perfectly and the language of which was as familiar to him as Italian. This is evident from the observations on painting that he wrote in hand and to which he related particular passages

*Opposite: Saddled horse, c. 1615-18*

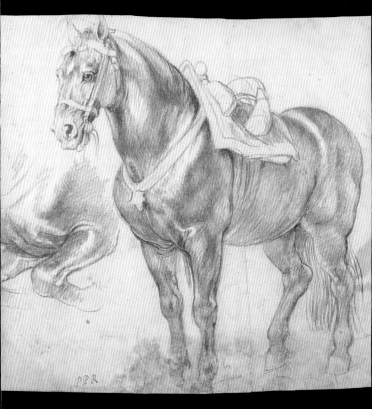

from Virgil and other poets appropriate to his subject. One should not be surprised therefore to find that such abundance of ideas, such richness of invention, such learning and precision in allegorical painting were his and that he articulated his subjects so well, only allowing in their composition that which was proper and particular to them. Having perfect knowledge of the action he wanted to represent he consequently entered into it more fully and animated it more completely, but always in accordance with nature.

He rarely visited friends but he received those that visited him so well that, besides men of taste and of letters, no stranger of whatever rank passed through the city of Antwerp without going to his house, as much to see him as to see his cabinet which was one of the finest in Europe. Prince Sigismund of Poland and the Infanta Isabella, among others, paid him this honour on return from the siege of Breda.

If he paid few visits he had good reasons for it, but he never excused himself from going to look at works by painters who had expressly asked him, and to whom he gave his opinion with fatherly kindness, sometimes taking the trouble to retouch their paintings.

He never condemned a work, always finding

beauty in every manner. Though he drew and copied many things in Italy and elsewhere, and though he owned a great many fine prints and antique medals he did not fail to retain young men in Rome and in Lombardy to draw everything beautiful for him which he later used to stimulate his imagination and fire his genius as occasion demanded.

Having hatched the ambition in his last years to find in life a tranquillity even greater than the one he currently enjoyed, he bought the estate of Steen, situated between Brussels and Malines, where he sometimes retired in solitude and where he took pleasure in painting landscapes after nature, the lie of the land in that country attractively combining meadows and mountains.

Simple practical skill is not enough to study in Italy in the manner that he did, one must also be learned and capable of profound reflection; many of the drawings he made in pen and ink are accompanied by reasoned comments and quotations from authors. I have seen one of his sketchbooks of this kind in which exposition and discourse are combined. There were observations about optics, about

*Overleaf: Autumn landscape with a view of Het Steen in the early morning, c. 1636*

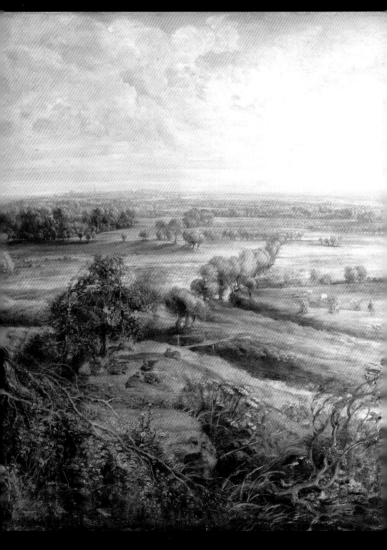

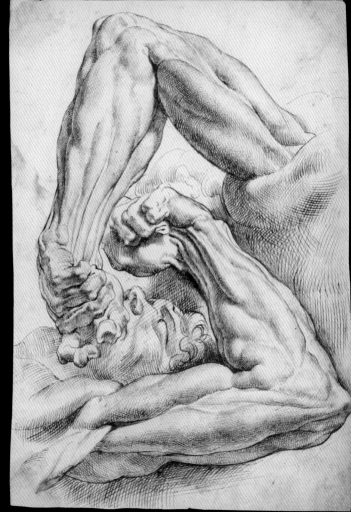

light and shade, about proportion, about anatomy and about architecture, and very remarkable reflections on the passions of the soul and on actions variously described by poets with visual expositions after the greatest masters in ink, principally after Raphael, in order to show off to advantage the painting of certain actions by the poetry of others (no matter whether these painters worked according to principle or only by the strength of their genius). There are battle scenes, storms, games, putti, agonies, deaths of various kinds, and other similar passions and events some of which, it was evident, he had also drawn after the antique.

Rubens was so greatly practiced in all parts of his art that he had no sooner drawn than painted; consequently there are almost as many small paintings by his hand as large ones, of which the former are the first ideas, the sketches. And of these sketches there are some that are very slight and others fairly finished, according to his greater or lesser command of what he was doing, and whether he was in the mood to work. There are even some that served him as models, sketches in which he had studied after Nature objects that he needed to represent in a large

*Opposite: Anatomical Studies, c. 1600-1610*

work and which he altered only as necessary. Given this, do not be surprised at the almost infinite number of his paintings, or if I tell you that, notwithstanding the great affairs he was obliged to attend to, never has a painter produced more works. The greater part can be seen in prints of which the best have been engraved under the direction of Paulus Pontius, Lucas Vorsterman, Bolswert and Pieter de Jode, all four excellent engravers.

At last, in 1640, having lived so usefully for his Prince and for his country, and so gloriously for himself, he died at the age of sixty-four and was buried at the church of Saint James at Antwerp where his widow and his children raised an epitaph in a chapel built in his memory.

# ROGER DE PILES

*Reflections on the Works of*
*Sir Peter Paul Rubens*

**from**

*The Art of Painting*

1699

(English edition 1706)

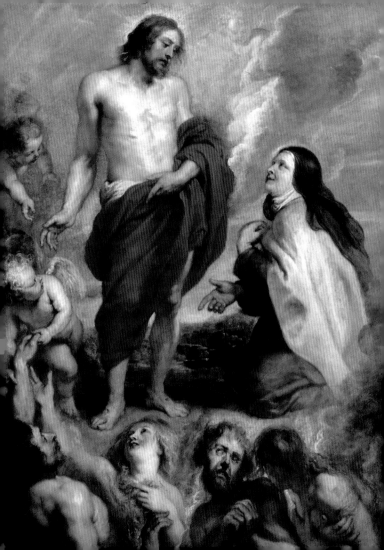

It is very easy to perceive by the works of this Painter, that his genius was of the first order, which he cultivated by a profound knowledge in all sorts of literature, by a nice enquiry into everything that had relation to his profession, and by indefatigable labour. Thus his invention was ingenious, and accompanied with all those circumstances that were worthy of a place in his subject. He painted in all kinds, often the same things, but very differently. No man ever treated allegorical subjects so learnedly and clearly as Rubens; and as allegories are a sort of language which constantly ought to be authorized by use, and generally understood, he always introduced those symbols in his pieces, which medals, and other monuments of antiquity, have rendered familiar, at least, to the learned.

As his invention was ingenious, so his disposition was advantageous; every particular object in his pictures was seen with pleasure itself, and contributed also to the good effect of the whole together.

Though Rubens lived seven years in Italy; though he made a considerable collection of medals, statues, and engraved stones; though he examined,

*Opposite: St Theresa interceding with Christ for the* converso *Bernadino da Mendoza, who is freed from Purgatory, 1630-35*

understood, and extolled the beauty of the antique, as appears by a manuscript of his, the original of which is in my custody, yet, through education, and the nature of his country, he fell into a Flemish character, and sometimes made an ill choice, offending against the regularity of design: however, though this is a fault that is blameable wherever it is found, and though his knitting of the joints is a little too extravagant, yet the best judges must confess, that Rubens was very far from being ignorant in designing; for in most of his pictures he has shewn a great deal of penetration in it. There is a piece of his drawing in the city of Ghent, a representation of the fall of the damned, in which there are near two hundred figures designed with a good *gusto*, and very correctly.[1] By this we may perceive, that Rubens' errors in designing proceeded from the rapidity of his productions.

There are abundance of his pictures at Paris, especially in the Luxemburg galleries.[2] I refer the impartial critics to those pieces, and they will find

1. 1620-21, Alte Pinakothek, Munich, ill. opposite  2. The Marie de' Medici cycle, 1621-25, Louvre, Paris; see note p. 42 and ills. pp. 4, 43, and 78-79

*Opposite: The Fall of the Damned, 1620-21*

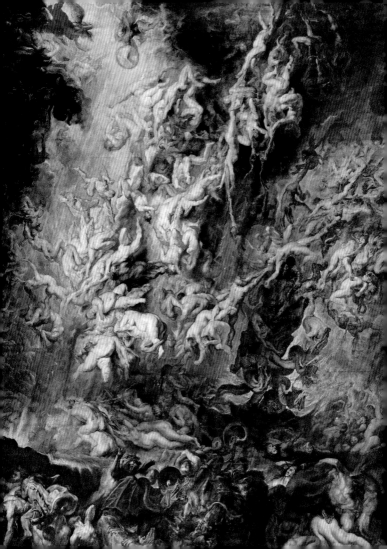

enough, in the divinities and principal figures at least, to satisfy the nicety of their judgement.

He expressed his subjects with equal energy and perspicuity, to which be added nobleness and grandeur. His particular expressions are suitable to the subject. The spectator is everywhere moved by them, and there are some of them of a sublime character.

His attitudes are simple and natural without coldness, contrasted and animated without exaggeration, and varied with prudence.

His figures are adjusted with a good *goût*, and his draperies are set with art. They are diversified and agreeable to the sex, age and dignity of the persons represented. The folds are large, well placed, and expose the naked without affectation.

He has shewn as much judgement in his landscapes as in his figures; and when he represents prospects naturally ungrateful and insipid, as those of Flanders are, he renders them picquant by the *claro obscuro* and by the accidents which he introduces into his composition. The forms of his trees are not very elegant. They resemble those of his own country too much, and his touches are not as fine as Titian's.

His architecture is heavy, and has something of

the Gothic in it. He often makes use of the licences; but they are judicious, advantageous, and imperceptible.

Everything that depends on colouring is admirable in Rubens. He advanced the knowledge of the *claro obscuro* more than any Painter ever did, and shewed the necessity of it.

By his example, he made the method of pleasing the eyes a precept. He collected his objects after the manner of a bunch of grapes, of which the grapes that are in the light make altogether a mass of light, and those that are in the dark, a mass of darkness. Thus all the grapes making one single object, the eyes behold them without distraction, and may at the same time, distinguish them without confusion.*

* Translator's Note (1706): We have been literal in rendering it into English in this place, and because monsieur de Piles has examined it better in his observations on monsieur de Fresnoy's *Art of Painting*, we shall add that explanation to this here. His words are these:

*Titian, by this judicious and familiar comparison, means that a Painter ought to collect the objects, and to dispose them in such a manner as to compose one whole, the several contiguous parts of which may be enlightened, many shadowed, and others of broken colours, to be in the turnings, as on a bunch of grapes, many grapes, which are the parts of it, are in the light, many in the shadow, and the rest faintly coloured, to make them go farther back: Titian once told Tintoretto, that in his greatest works a bunch of grapes had been his principal rule, and his surest guide.*

This assemblage of objects and light is called a group, and let the number of the figures that enter into a composition be never so great, Rubens never made above three groups in one piece, that the sight might not be scattered by a multiplicity of objects, alike sensible and exposed. He also industriously concealed the artifice as much as possible, and only those that understand its principles can discover it.

His carnations are very fresh, each in its character. His tints are just, and employed with a free hand, without being jumbled by the mixture, for fear they should sully and lose too much of their lustre or truth, which appeared in them when the first work was done. Rubens observed this maxim with the more care, because his performances are grand, and consequently to be viewed at a distance; wherefore he endeavoured to preserve the character of his objects, and the freshness of his carnations.

To this end, he not only did his utmost to keep his tints pure, but he made use of the most lively colours to have the effect he intended. He succeeded in his endeavours, and is the only person who understood how to join a great lustre to a great character of truth; and, among so much brilliant, to maintain a harmony, and a surprising force; for which reason we may reckon the supreme degree, to which he raised

the colouring, to be one of the most valuable talents of this Painter.

His labour was light, his pencil was mellow, and his pictures finished; but not like some Painters, who with overstraining and earnestness of finishing their pieces, do them more harm than good. He had several disciples who executed his designs; on which account many pictures are attributed to him that were not of his doing. His own works, to which he gave the last hand, shew, that never Painter was more easy in the execution of his designs, and that the wonderful effect which they have on the eyes of the spectator, did not proceed so much from his consummate experience, as from the certainty of his principles.

List of illustrations

All oil on panel unless otherwise noted

Image credits

© 2005, 2019 Pallas Athene (Publishers) Ltd.

**Published in the United States of America in 2019 by the J. Paul Getty Museum, Los Angeles**
Getty Publications
1200 Getty Center Drive, Suite 500
Los Angeles, California 90049-1682
www.getty.edu/publications

Distributed in the United States and Canada by the University of Chicago Press

Printed in China

ISBN 978-1-60606-623-2

Library of Congress Control Number: 2019931763

Published in the United Kingdom by Pallas Athene (Publishers) Ltd.
Studio 11A, Archway Studios
25–27 Bickerton Road, London N19 5JT

Alexander Fyjis-Walker, *Series Editor*
Anaïs Métais, *Editorial Assistant*

Front cover: Peter Paul Rubens, *Self-Portrait* (detail), 1623. Oil on panel, 85.7 x 62.2 cm
(33.7 x 24.4 in.). Picture Gallery, Buckingham Palace, Royal Collection, RCIN 400156.
Photo: ©Royal Collection / HIP / Art Resource, NY

Note to the reader: Giovanni Baglione's *Le Vite de' pittori, scultori et architetti* was published in
Rome in 1642. It had allegedly been reworked for publication by a literary man named Ottaviano
Tronsarelli. The *Life of Rubens* from that work has been translated by Lisa Adams. Joachim von
Sandrart's *Teutsche Academie* was published in German in 1675 and in Latin in 1683. The *Life of
Rubens* has been translated by Dr. Kristin Belkin. Roger de Piles' *Dissertation sur les ouvrages des
plus fameux peintres* was first published in Paris in 1681. The *Life of Rubens* has been translated
by Dr. Katie Scott. De Piles' *The Art of Painting with the Lives and Characters of above 300 of the
Most Eminent Painters* was first published in Paris in 1699, and the *Appreciation* is taken from the
English translation by John Savage, published in 1706.